UMBRA

WRITTEN BY M. M. RODRIGUEZ

PHOTOGRAPHY BY
ISELA RODRIGUEZ

Copyright © 2023 M.M. Rodriguez, All rights reserved,
Photographs Copyright © 2023 Isela Rodriguez, All rights reserved.

No part of this publication may be reproduced, stored in a retrieval system or transmitted in any form or by any means, electronic, mechanical, photocopying, recording or otherwise, without prior permission of Halo Publishing International.

For permission requests, write to the publisher, addressed "Attention: Permissions Coordinator," at the address below.

Halo Publishing International
7550 WIH-10 #800, PMB 2069,
San Antonio, TX 78229

First Edition, October 2023
ISBN: 978-1-63765-479-8
Library of Congress Control Number: 2023915040

Halo Publishing International is a self-publishing company that publishes adult fiction and non-fiction, children's literature, self-help, spiritual, and faith-based books. Do you have a book idea you would like us to consider publishing? Please visit www.halopublishing.com for more information.

To the girl who is always thankful,
even though the odds are often stacked against her.
To my sweetest, most honest friend, Elaine.

DRY

I want to just sit and cry.
What else is there to do
when the wonders of the Earth run dry?
As the world falls apart, into pieces,
all I do is survive.
I yearn to do more.
But it's easier to stand by.
I am a speck of dust in a dust storm.
And though I give,
it is never near enough.
My soul is anguished,
so it doesn't rest.
I long to do more,
but for now, I stress.
I wonder what will become of the world and me?
I'll be left feeling
powerless and restless
if it ends soon.
I will die guilty and defeated,
saddened that the Earth's depleting.

SPECIAL

Is there enough room in the boat for everyone?
So many people truly believe they are the one.
How many ones can there possibly be?
I used to feel so special, believed I was unique.
I hoped and dreamed it would be me.
But every time I wasn't picked,
my certainty began to dwindle.
My faith fading and hope dissipating,
I slowly began to feel uncertain.
My confidence a void.
If there are plenty of people like me,
how special could I truly be?
Here I sit, dejected and dispirited,
knowing that I'm just another drop in the ocean,
someone who will remain unseen.
All I can do is hope and dream
that there will be enough room in the boat for me.

Life

Life is not what I thought it'd be.
It's the opposite of what I dreamed.
One day you can be so happy,
but the next day everything can go wrong.
In spite of every dreadful thing,
you have to pretend everything's okay.
Maybe luck one day will find you.
Maybe you'll get to leave the pain behind you
If only peace and love could live inside you.
Life can be unpredictable,
but I really wish it'd go easy on me.
I've had some pretty awful days,
and I hope, one day, things will go my way.
If only my heart could speak for me
and show this life all the things that I can be.
I'm not the worst,
and I do try to put forth the best of me.
But is it worth it?
I wish I could find out if things get better.
If only life could promise me a truce,
Oh, how happy life would be!

GUILT

Is it wrong to want too much?
Is there a limit to dreams?
How greedy is it, really, if you want to share it all?
Can anything be measured?
Am I wrong for constantly wanting to feel fulfilled?
There is always guilt in my veins,
for not being satisfied with the life I have been given.
As if striding for more is a sin.
It is I being egoistic, when I should be grateful.
What makes me think there is more out there for me and mine?
Why does luck fall upon some, but not all?
I wish I could speak to someone who has all the answers.
I would ask so many questions
to try and make sense of how destiny is determined.
To be fair, I am grateful for the life I have,
but that doesn't sway me from wishing there were more to everything.
May the guilt I feel be laid to rest someday.
It doesn't feel right to feel wrong about yearning for things.
I hope to satiate my wants one day.

ENVY

I'm so green with envy.
It is so hard to concentrate
when all I can think about is how to earn a living
without killing myself from exhaustion.
Do wealthy people ever consider how lucky they are?
Or do they take for granted that peace of
not having to worry about making ends meet?
Budgeting the life out of every paycheck,
trying to figure out what to do to save money on bills.
Always thinking of a meal plan that won't
cost you half your paycheck.
I wonder if they ever notice there's a world
out there fighting to survive.
They spend thousands on clothes and cars.
Meanwhile, most of the world is just scraping by.
I hope, if I ever end up in their shoes,
that reality never leaves me, and it pushes me to make a difference.
May the envy that lives within me now
not make me bitter,
but let it push me forward towards a life
where money woes are a thing of the past,
and my only goal is helping those who
struggle in life.

UFO

If I ever saw a UFO,
I wouldn't have the strength to run away.
I'd probably lift my hands in surrender.
I'd sign for them to take me,
no desire within me to fight.
A true alien should be able to read my mind.
They'll see me thinking of the things I'd love to lose.
My bills, my job, my aching joints, and my miserable choices.
That's encouragement enough to make me
beg them to take me.
There isn't much I'd miss, besides
my husband, dogs, and some friendships.
I'm so done with daily struggles.
But because I'm so unlucky,
I know I won't ever see a UFO,
so here I am, left to continue with my own sad devices.

Alone

If you are someone with a struggle,
and you have a restless heart
and a very anxious mind,
I must let you know that makes two of us now.
The world may seem forlorn and dreary,
so full of sadness and lost spirits,
and it is, but there are reasons to endure this life.
If we could come together
and lean on each other and trust,
we could gain strength from each other's pasts.
When we share stories,
we release the burdens from our souls.
There is so much darkness in the world.
It can overshadow the good times we've gone through.
Do not let bad moments overtake the good ones.
If you're running low on strength,
it's okay to ask for help.
Odds are you will find someone
who is just as stuck as you feel.
Life is usually easier to tread through
when you have someone to lean on.
Together, we can make it out alive.
Alone, we can barely just survive.

MORE

I am sitting here with a roof over my head,
food in my fridge, and a job full of work.
That should be enough to make me happy.
Yet here we are again.
I feel dissatisfied with the way things are.
How is my brain wired, that it never stops wanting for more?
Why isn't what I have now enough?
I only make myself more miserable,
thinking of all the things I'd like and don't currently have.
What type of selfish, shallow being have I become?
There are real tragedies taking place around the world,
but here I sit with my petty desires.
So out of place are they.
I wish that I could change them.
I would like to be a better me,
to sympathize and put forth all I own
at the feet of those who need it more.

Tired

My mind is mighty tired.
My body quite fatigued.
But I have to keep on living
because life is not a dream.
In the mornings,
when sunbeams shimmer through my window,
I'm reminded I'm not dead.
To be honest, I should feel blessed,
but in my tiredness, there's dread.
Every day should be a new day,
But in reality, there's hardly any change.
We rise; we work; we eat, get home, and sleep.
You may add a task or two, but it mostly stays the same.
This routine's driving me crazy!
I so wish my life would change.
I hate these daily struggles!
And so what if I'm not content!
Am I not allowed to feel my feelings?
I can be selfish if I want.
I shouldn't always have to feel okay.
If I'm not hurting anyone, I should be able to complain!
Until my guilt reminds me
that my life, compared to others', is not as bad as it could be.
But my feelings are still valid, and I don't have to be ashamed.
I am me, and you are you.
Please don't tell me what to say or feel.
My mind belongs to me, just as yours belongs to you.

Negative

Just call me Negative Norma.
You've heard of Debbie Downer.
Well, she's my cousin, and we're related to the core.
Like her, I'm hardly joyous;
I'm actually quite unpleasant.
There has never been an instance
when my mind hasn't longed for so much more.
Wondering, why are some people luckier than others?
Some people grew up with a father and a mother.
Then you have some who grew up with one.
While you have others that grew up with none.
So who picks which life a soul belongs to?
Why can't a soul pick to which family it's born?
What kind of being allows a soul to suffer
through a life of horror chosen for them before birth?
I wish there were an Undo button we could press
to escape the cursed life we were given.
If only that button were real and we could reset
in order to transport the good souls
to a more deserving life.
So I sit here, a Negative Norma, wishing for a Reset button,
knowing I will never get it.
My soul is not deserving; it's honestly quite pathetic.

Joy

What is joy?
Where can I see it?
Where can I find it?
Who gets to keep it?
I want it to stay forever
to give my dull
feelings some life.
My soul is currently sleeping,
dreaming about the meaning of life.
My mind is mostly numb now.
Life is not what I wanted it to be.
What's the use of anything?
Even my skin wants to peel off my body.
My hands, though
they want to touch and feel everything.
But it all slips away so quickly.
I could never be a wallflower.
A wall flower is still a flower,
and I'm much too plain for that.
Somewhere out there,
there's desire; I hope it finds me, stays with me,
and never looks back.
Hope it makes up the time with me,
for all the years I was without.
Meaning of Life, please find me.
I'm tired of feeling sad.

Human

Being human is a challenge.
We live to work, and then we die.
We have limited time with so much to lose.
Being human and being sane
is not my reality.
Being human is a burden.
Being human is always running out of time.
It's waking up each morning,
dreading every single day,
not knowing what to expect.
Being a decent human being
is the toughest achievement in a world full of twits.
But if you should try it, you will find
it's the most rewarding thing of all.
Being human is a challenge.
But since I've never been anything else,
I don't have much to compare it to.
I often wonder what it would be like to lose my mind.
What would it be like
to know no rules?
If I had nowhere to be,
no one to please,
unlimited time with no expectations?

I think I would kiss every damn tree,
hug every flower,
catch some butterflies, and then set them free.
I'd mow the grass, because secretly I love the smell.
I would eat all the figs and the berries.
Run around barefoot,
pick all the peaches and apples,
take one bite, and toss them.
I would go to bed late
and wake up even later.
There'd be no alarm clocks,
just the sun, the moon, and shooting stars!
I would reread my favorite books,
write the corniest poems,
and dream for hours.
I'd hug all my dogs
and nap with them.
There would be no cars, no bills, no sickness,
just stone farmhouses.
No snakes, no crocodiles, no spiders, no creepy insects.
More fireflies, ladybugs, and butterflies.
I would have less stress, more love,
more happiness.
With so much time, I would have no worries
because, if not today, there would be tomorrow.

Longing

This longing that I have in my soul,
it does not let me live in peace.
I'm constantly fighting with my mind,
telling myself it cannot be.
Because why me?
Though it hurts to admit,
there is someone out there more deserving,
with a clean conscience and a better disposition.
Yet hope is the last thing to die.
I could beg, I could cry, and then what?
Manipulation won't work this time.
This is not a person one can convince.
This is the luck of the draw.
Has anyone ever controlled luck?
When the odds lie against you,
there is no one to call, no one to save you.
No one can change destiny.
Hope! I have to let it go.
To live this way, it's such a torment.
I am again just a grain of sand on a beach.
Too tiny to stand out, too insignificant to count.
So I'll live with this longing
because there is no prize for me.
And I have to accept this is the life for me,
to be always longing, yearning
for something that will never be.

MEANING

What is the use of living?
What's the meaning of life?
Where does my happiness lie?
What is it that I'm searching for?
I've never known where I belong.
There's a voice inside my head.
She is my restless ego.
She mostly hates me.
But there are days she feels bad for me.
She reminds me daily of all the things I don't have.
She wishes I were different.
She wishes I were charming, special, sweeter.
Sometimes I wish her arrogance would push me,
enable me to be better, try harder, and live smarter.
But I can't be what she wants me to be.
Somewhere in my childhood,
my confidence dissolved.
I was stuck simply surviving.
A little kid yearning for love.
Instead of helping me,
she simply judged me and made me feel so small.

WILL

I've done it yet again.
I have lost the will for life.
No matter how hard I try,
I'm barely scraping by.
My throat is getting tighter;
my pulse is racing now.
I don't know where life is going;
It's just swiftly floating by.
One day when I'm less tired,
I'm hoping to step down,
to feel the ground beneath me,
and feel the Earth's pulse beat within me.
Oh, Wind, if you could hug me!
Embrace me with such force;
remind me this is temporary
as you fill my lungs with joy.
Please, Nature, help me find the will I've lost.
As life is not yet ready to let me stay behind.

CANDLE

I have a little candle.
So it flickers anytime a light wind hits.
I must take care to keep it lit,
or I run the risk of being left in darkness.
This little candle lights my path
when it's too dark to see.
When a window is left wide-open,
there's a breeze that can sneak in.
Without my candle, I would stumble.
And then, who would help me?
The thought of being left without it
sends shivers down my spine.
This candle is the strength
that's been keeping me alive.
Like the blood in my veins,
It's the reason I'm here today.
To lose it means to perish.
So I have to keep it lit.
Dearest Candle, you're so precious.
Don't leave me in the dark.
If there is one thing
I'm so sure of it's that I need you in my life.

Frail

My mind is pretty frail.
I'm obsessive all the time,
constantly trying to evade this pain.
How do I make it stop?
What if next time I fail to alleviate my body.
There is such pain in my head,
and it rapidly spreads to every joint in my body.
This is no way to live.
In my sleep, I often cry.
It's this helplessness that knocks me down.
How much agony can a human body take!
Every second of every minute, there is pain.
I breathe in, and I breathe out.
Just barely holding it together,
hardly prevailing.
Hanging on by a thread.
When will there be peace within my body?
I'm so very tired.
I can no longer make it through.
This is it for me;
don't feel bad for me.
My mind and body deserve some peace.

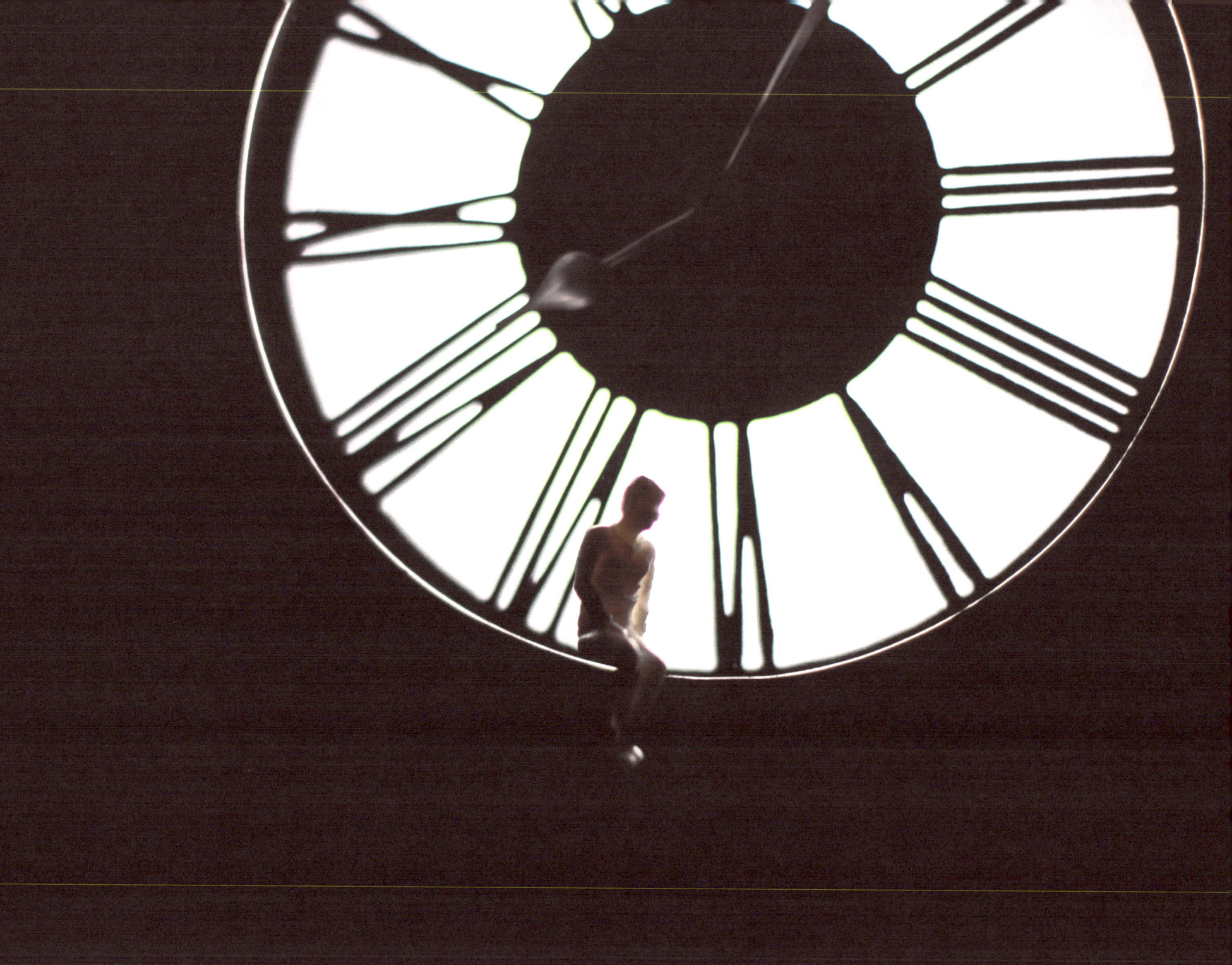

Good

I don't know what to do.
My dreams aren't coming true.
Do I give up hope, and move on?
Or do I press forward and possibly waste more time?
What more can I prove to demonstrate I try!
I wish to be a better person.
So what else can I do to show I mean to stand for good?
Do I plead and cry?
What more can I contribute to prove I'm honest!
If there is bad in me, erase it
because I'm running out of time.
My mental health is waning.
Each day my dreams evade me.
My spirit crumbles.
Again, I ask out loud,
Why not me?
Let me win for once.
At least tell me what is wrong with me.
All I want is to be better than the old me.
If that's too much to ask,
then let my dreams be nothing,
for at least one cannot miss nothing.

EXASPERATED

I'm constantly exasperated.
Often hoping to leave my skin.
Wishing that getting rid of stress
were as easy as losing hair in the shower.
Do problems ever end?
You go to bed with two problems,
only to wake up with four.
I'm moody all the time.
To say it's the little things that count
does not make sense to me.
It's the bigger things that stand out the most.
Give me a raise I can finally be happy with.
Write me song that came straight from your heart.
Build my dogs a playground
so they may have fun and explore all day.
Treat me to a home-cooked meal
more often than just on the weekends.
Life with its trials and tribulations can waste away a soul.
A surprise here and there could lighten up my load.
Today I don't want to put me last.
All I want is to feel lucky and be relaxed.
I want to feel elated without being made to feel an ass.

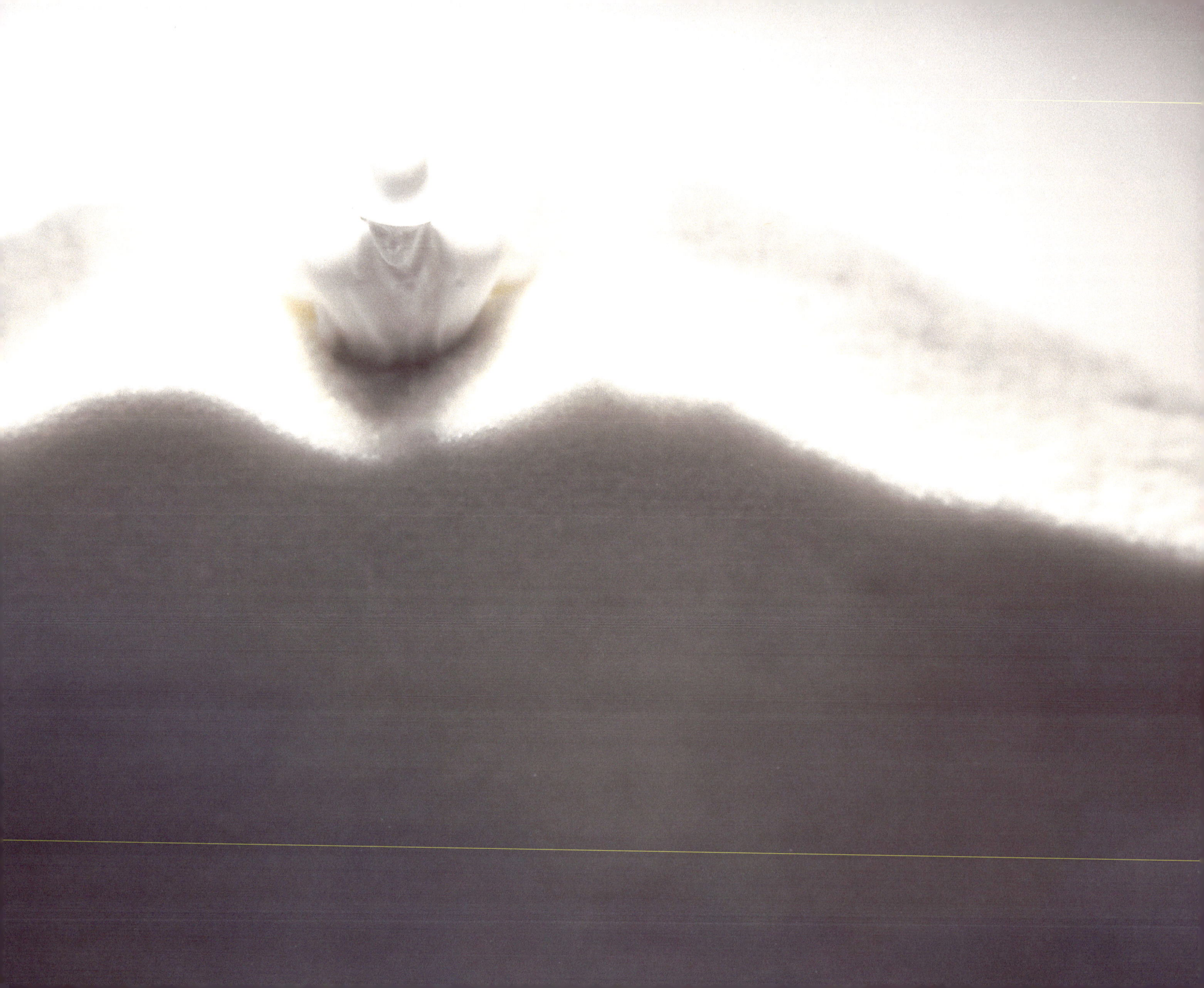

Doomed

Am I doomed?
Am I to live a life of dread?
If so, take me now, for I am very tired.
My brain is slowly dying.
It does not let me concentrate.
All it does is bring me down.
Futile was the hope I used to carry.
Thirty-four years of living
and nothing about me is worth sharing.
Accomplishments?
There are none.
Talent?
Nonexistent.
Trauma?
That I have aplenty!
Abuse?
I know it very well.
Neglect and I were intimate,
as we were often left alone.
Love?
I found as I got older.
Trust?
I'm always working on.
Anxiety and I are one,
but I hope someday it leaves me,
because I want to live my life in peace.

Brave

I'm happy if you're happy.
If you're sad, then I am too.
Let nothing come between us,
because there should always be a me and you.
Know I'll be there for you always.
No matter where, no matter when.
Regardless of the hour.
For now, please keep on living.
I won't be sad; I won't be mad.
I only want to see you flourish.
Don't let the sorrow get you down.
You hold the courage in your heart.
I'll make you brave when you're afraid.
I'll give you peace when you're in need.
You must be strong throughout the pain.
In the end, you'll be okay.
Remember me when you feel lost.
You may not see me,
But I'll be there.
Just close your eyes;
You'll see my clearly.
For now, just know I'm doing better.
I found the peace I always longed for.
In this new world, my life's restarted.
Do not be sad;
someday we'll be reunited.

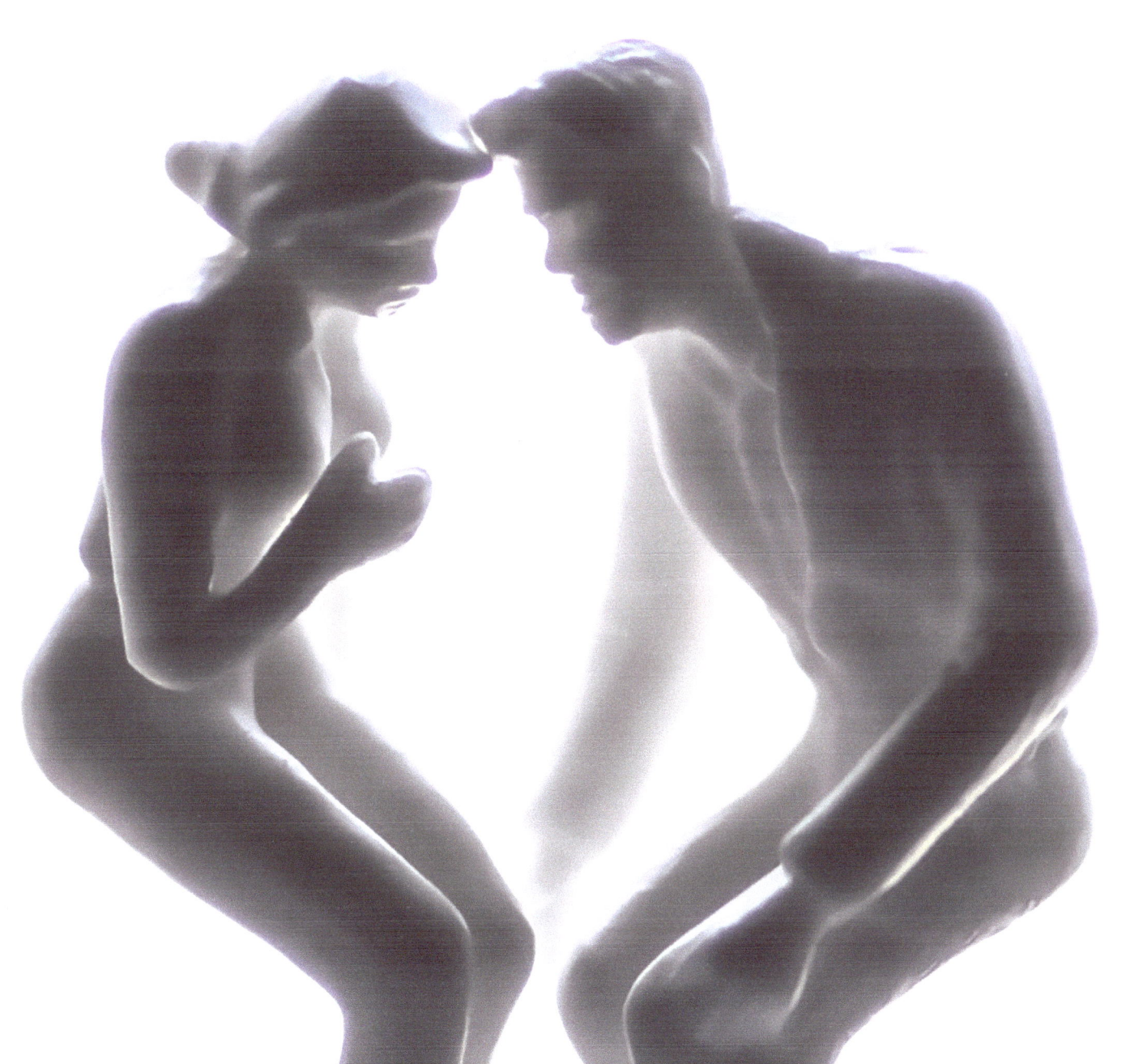

Sun

Could I survive without the sun?
To miss its heat upon my skin,
I'd rather not!
I never want to be without it.
For who could ever take its place?
Life could not survive in darkness.
There would be no plants, no trees,
and therefore no birds and bees.
The Earth would die, and so would we.
Some people wish upon the stars at night,
but I always wish upon the sun.
It brings me spring; it brings me summer.
My favorite seasons where I may recover.
It's easier to smile
when I can smell the flowers.
When I can see the ladybugs, the butterflies,
and the fireflies at night.
When I can feel the wet, warm sand under my feet
and enjoy the coolness of the ocean breeze.
When I can hear the cicadas sing,
the crickets chirp, and the frogs croak.
I can forget my troubles
when the sun shines
and nature blooms.
I'm thankful for its warmth and joy.
Nothing can ever take its place.
It will always be one of my favorite things.

Together

I keep thinking, Do not let me go,
convincing myself that there will be more.
Constantly placating the voice in my head
with false, unrealistic scenarios
of how life will get better.
How this bad break can't last forever.
But when does it end?
How much longer must I hold on?
In the end, I remember that I'm not alone.
I can't be alone.
In this world full of people.
There have to be others who struggle as I do.
I wonder what they do
when they're sick and tired.
If they can move forward,
then so must I too.
Together united in spite of the pain.
If we can join forces,
we may beat our troubling woes.

Mind

I can't do this anymore.
They say you fake it till you make it.
But the faking has taken a toll on me.
I'm falling apart.
I don't know if to laugh or cry.
I'm out of my mind.
My sanity has gone.
Was I ever sound of mind?
Why is it hard to remember?
Does depression affect memory too?
Panic, it's taking ahold of me.
I cannot breathe!
Tears fall down my face in resignation.
Clearly, there is no hope for me.
So many times, I have said I am tired!
And every time it's true.
The voice in my head is about to break out.
It has bided its time,
and it's ready to lash out.
Beware of us when it's unbound and freed.
I pity those who stand by me.

Memories

Who am I
but a person with plenty of hopes and dreams.
Nothing like a Monday
to bring you back to reality.
The weekends feel so short.
Never long enough to replenish your soul.
You blink once,
and then you're back at it again.
Working, struggling, wishing you could run away.
Good times, happy moments
never seem to last these days.
Forgive me, World,
there is something that I've got to say.
No matter what I do,
I always seem to feel this way!
Sad, mad, frustrated, and exasperated.
When do we get to see the fruits of our labor?
When does the misery end?
Dearest Earth,
please take me out.
Let me be reborn into a world without greed.
Where there is only love, friends, and family!

You

When I was a little girl,
I felt your wrath consume me.
I tried to hide within myself
to avoid letting your hateful words destroy me.
I blamed myself so many times
for not knowing how to make you love me.
If I could have bought your love,
I would have bought it in an instant.
And now so many years have passed,
yet here I sit with all the scars
that never healed within me.
There is one thing that's not the same,
and it's the way I do not pine for you.
I do not hope to win your love,
nor do I wish to hear from you.
You were horrid.
You were cruel.
You were absolutely wicked.
I wish to never be like you.
You were my biggest childhood bully.
A mother you were never meant to be.
I hope you found your peace away from me.
I'm glad I'm grown, and you can't
steal more life from me.

Fair

Nothing is ever meant for me.
No matter what I change or what I do,
I'll never find my way to you.
If life were fair, we'd all be equal.
But since it's not, we're all just doomed.
Inside of me I want to scream.
I hate it here; it's not for me.
There are many truths I long to tell,
but I just can't.
I'd rather eat my words and choke.
It's better than causing anyone pain.
This feels like weakness, to care too much.
I have all these feelings,
and I'd rather not.
All this caring comes at a cost.
Today, tomorrow, it just never ends.
When the day is over,
my mind's left thinking,
Why is nothing ever meant for me?
Does anyone worry about my being?
You give and you give
until you run dry.
So when will your day ever arrive?
How long do I wait for someone
to save me?
I think it's about time good karma repays me.

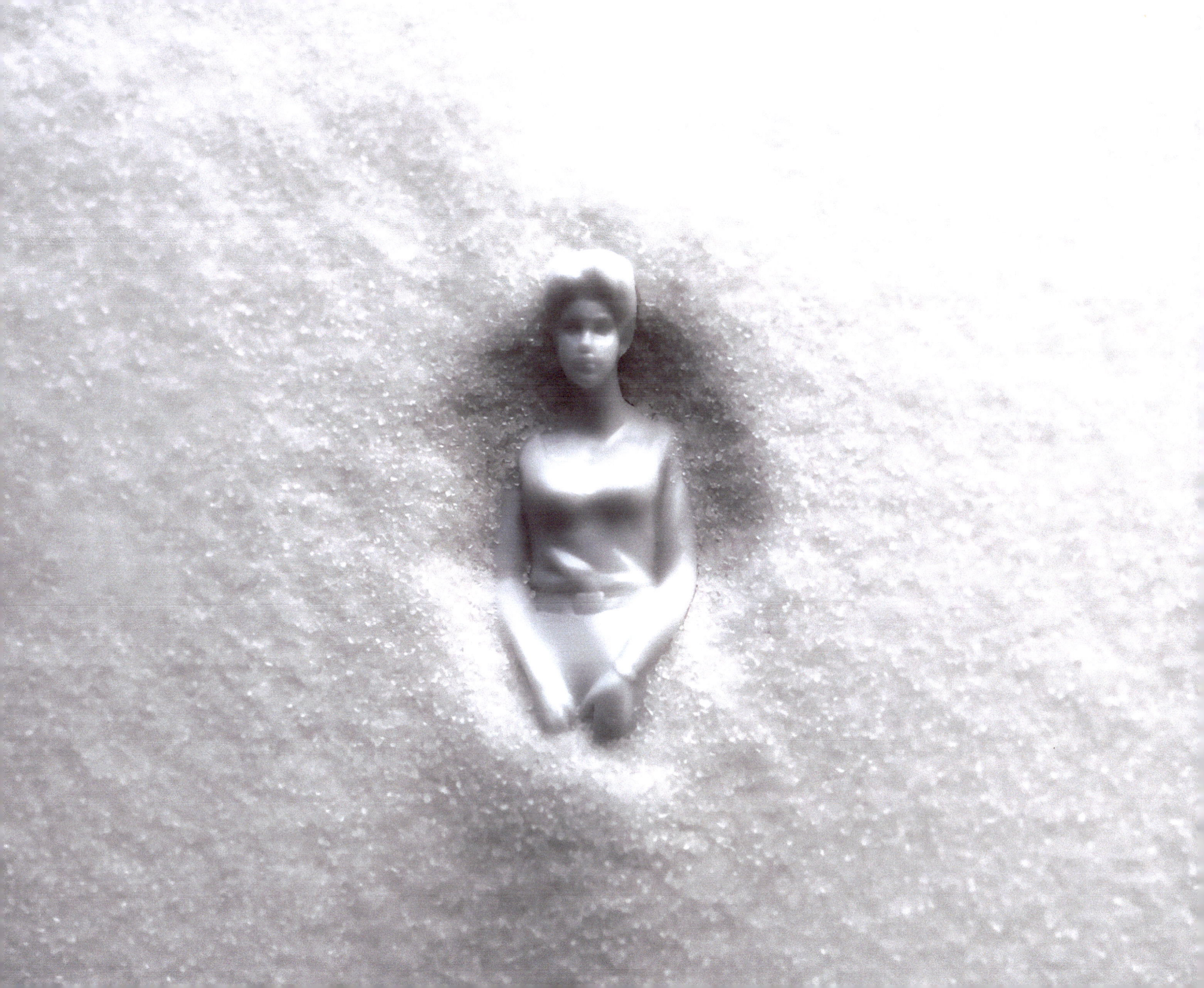

Temporary

If this is all temporary,
why do I even bother to build and achieve?
If I can't take anything with me
when I'm gone,
why do I stress about working hard?
All I do is buy and buy.
Yet it would all go on sale if I die.
Nothing will be left of me,
except memories and poems.
Maybe I should work to give,
and not to keep things for myself.
What's the use of being greedy?
It does not make you any friends.
I value friendships,
though I'm picky.
I like to spoil those I adore.
I feel so happy when they smile.
I've never felt more joy.
Perhaps my goals shouldn't be just for me.
But for everyone who is near and dear to me.

GRATEFUL

I know a girl who is always thankful,
even though the odds are stacked against her.
She takes on troubles as if they're puzzles.
And once she's solved them,
She feels so proud, and smiles, and is even grateful!
I do not understand this girl
who does not break and fall.
Instead of giving up, she stands so tall.
And though she must be tired,
She won't forgo the fight.
What sets this girl apart
is she does everything for her friends.
A single parent who works extra hours,
and still has dinner ready for her kids.
She loves her children and all her friends.
No one can call her fake.
She is truly one of the best.
She makes me smile.
She is the most loving person I've ever met.
Her life is a struggle,
yet she always pulls through.
I hope someday she will be blessed,
that all her goals and dreams are met.
I wish her to know that she is loved and valued.
She is the best of life,
and knowing her has made me a better friend.

Confusion

Living is confusion.
Half the time, it's taking risks.
Hoping that the path we chose
will be the one to bring us stability and joy.
Bracing ourselves for what is yet to come.
Second chances aren't always a given.
Treading lightly is a must.
Sometimes we try to have others choose for us
because we do not trust our own judgment.
Yet this is freedom.
Being able to set our own path.
Having the ability to live on our own terms.
But at times it is hard to decide.
There are forever consequences to every
decision.
This is why life is confusion.
Because we never know
what will happen.
We all walk on eggshells.
We are all just trying to survive.

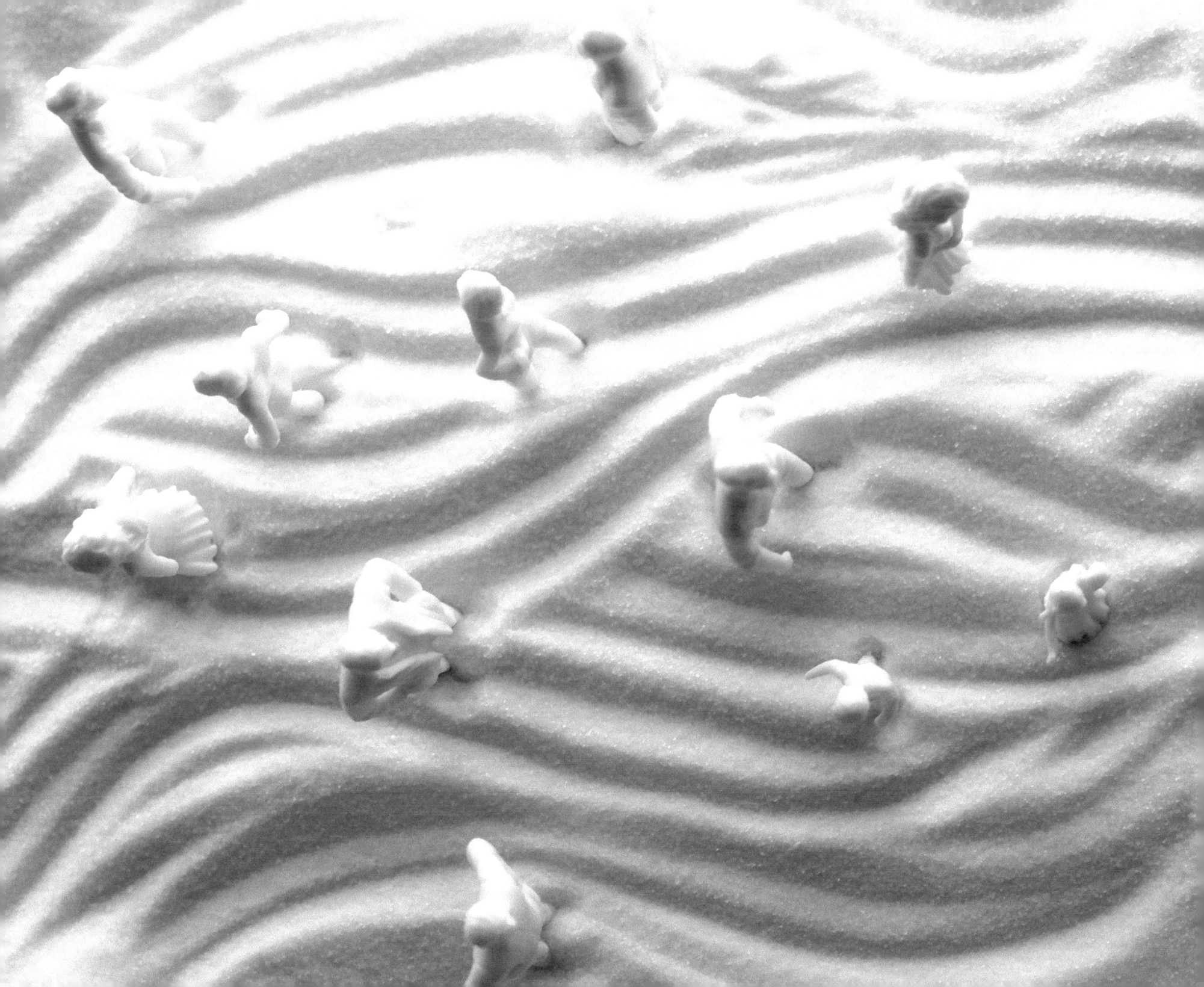

Rain

Rainy days with big gray clouds
are paradise to some.
To me, they suffocate what little joy I have.
I try to like the rainy days.
I know it's good for trees and flowers.
It's important for everything that lives.
But rain dulls my heart
and ruins my day.
I often think when it rains,
I hope it's not here to stay.
The gloom I feel when I see the rain
can be the hardest part of my day.
Please come at night, Rain,
While it's dark outside
and I'm in bed.
Let's make a pact,
and I won't talk smack.
You can take full reign of the night.
But don't come play during the day.
Please! We can both be happy if you agree.
The day for me and the night for you.
I hope this is something that works for you.

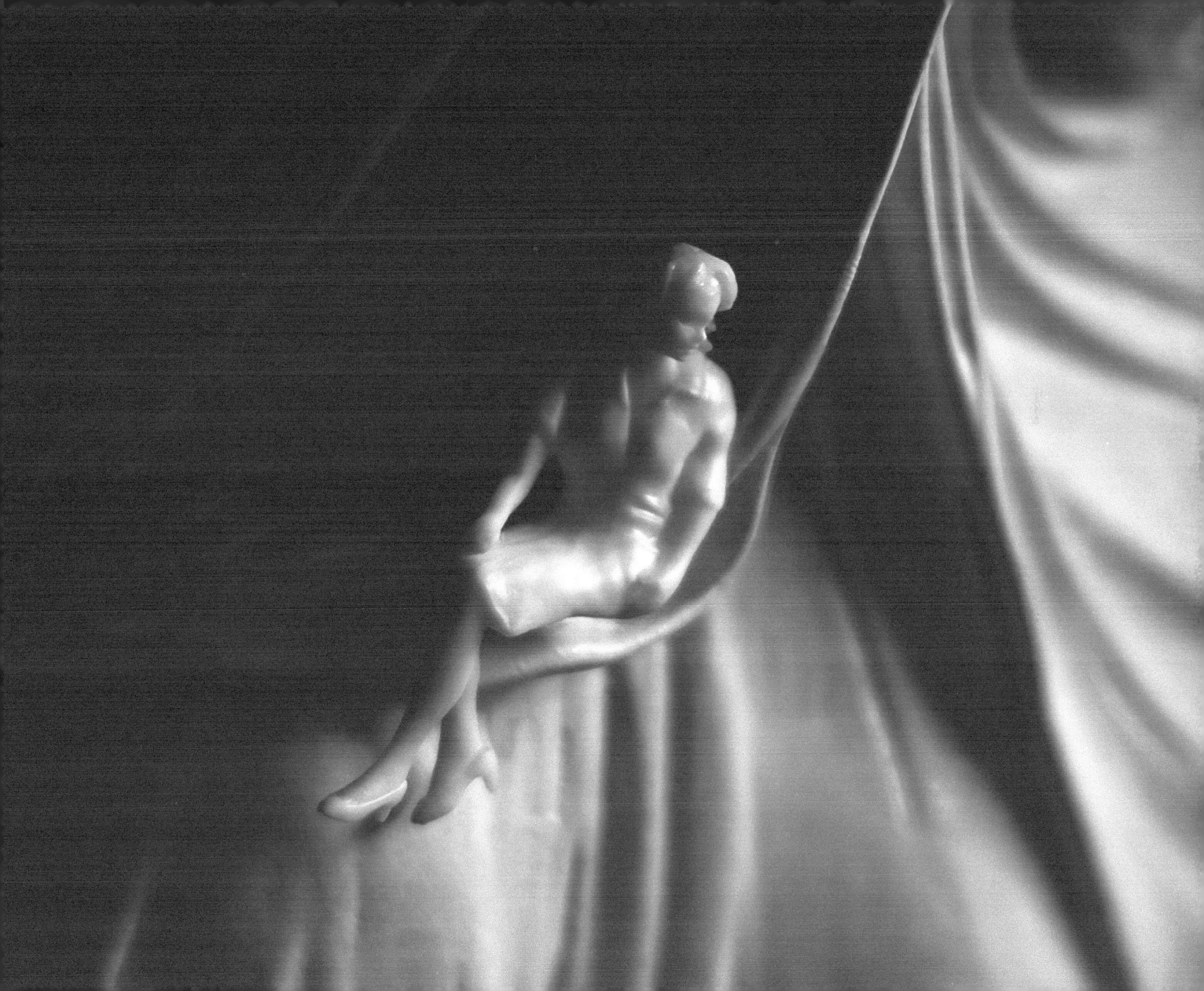

SAME

Swallow me, Earth!
For again I'm tired.
I've lived enough.
I don't want to try for another day
when the outcome will stay the same.
My mind is lost;
my soul's retired.
The shell of me is all that's left.
I won't keep fighting.
Take my body; bury it,
and forget everything about it.
I never stood a chance anyway.
Do not revive me.
I don't want to wake up
just to struggle again.
This is what it is, and I will be okay.

Yesterday

Yesterday was here,
and now it's all but gone.
The sad part is that Monday has begun.
It's not just me. I've heard it said from others too
that Monday's quite unpleasant.
No one likes to say goodbye
to the short-lived weekends
that serve for having fun.
Yesterday's my favorite day
when it falls on Friday, Saturday, and Sunday.
The rest of the days are simply okay,
and about them I won't complain.
But what if Tuesday were in place of Monday?
I'm sure we'd hate it too.
The same would go for you and me,
and for everything that exists.
If you were you with another face,
or if I were me with a different name,
someone would still not like us.
And in that sense, I can now relate.
For now I know it's not about you, or me, or Mondays.
We cannot change where we were placed.
What slight relief this brings to me.
To know it's not us personally.
Now I can say,
"Monday, you're okay.
I apologize for the contempt."

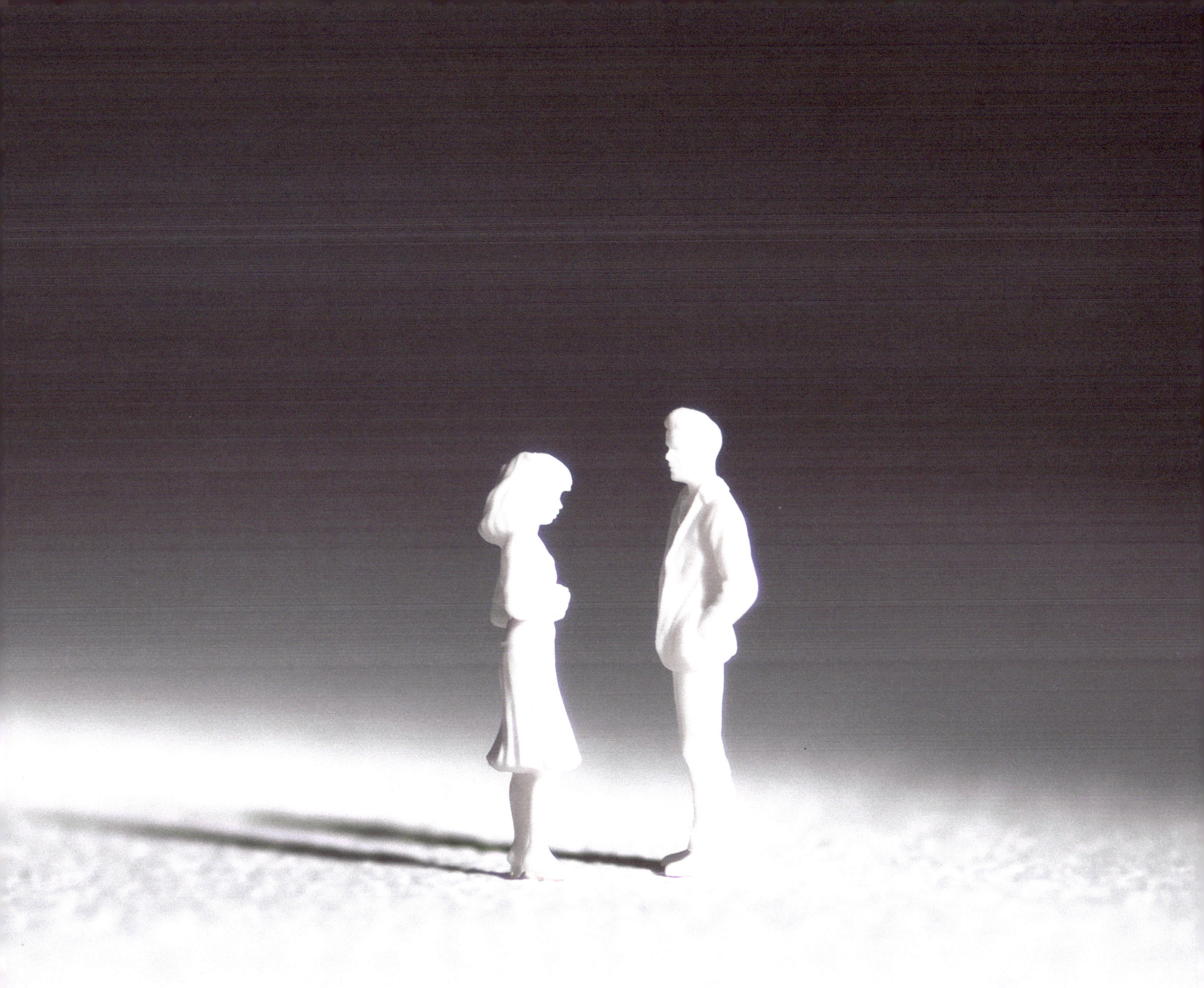

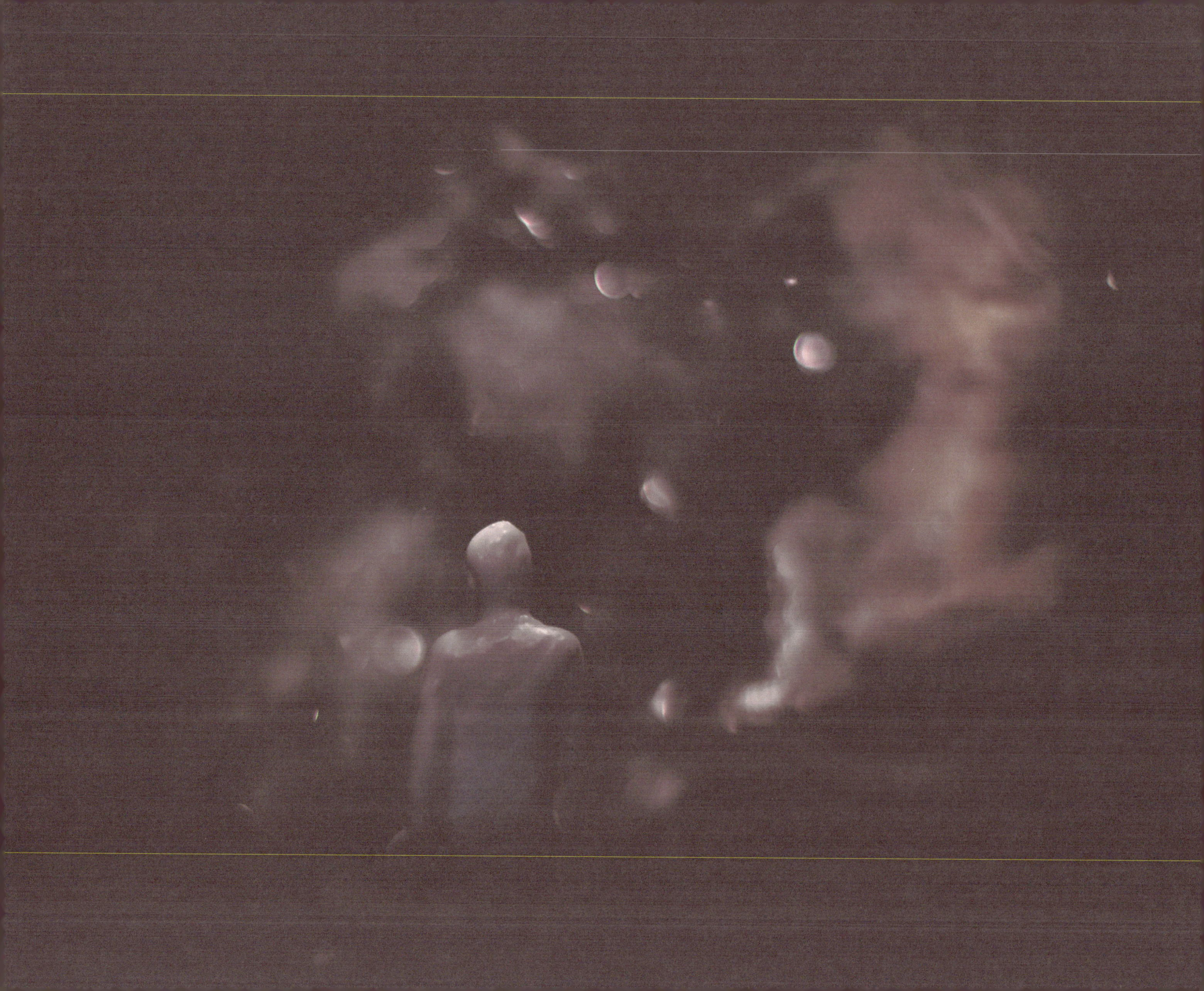

Stars

I want to see the stars at night
before streetlights go up and blur the sight.
I never paid them any mind
until one day I looked up at the sky
and saw them shining bright.
I couldn't help but stare at them in awe.
Suddenly I realized
they were like shiny crystals in the night.
I wish I had a telescope
so I could see them shine more clearly.
Next time, I will wish upon a star.
Perhaps they hold the luck I'm missing.
I wish to have the perfect words
to help relieve all souls.

Villain

It feels too easy to become a villain.
If I were to lose my mind,
I would lose it all.
In a moment of anger and rage,
I could set the world in a blaze.
That bright future I envisioned
could be lost with a rash decision.
When I feel myself getting furious,
I breathe deeply to relax.
Then I remember the things I would lose
if I gave in to my temper.
It can be hard,
fighting this battle.
I walked a thin line
before getting help with my struggles.
Thankfully, I haven't fallen,
and it's due to getting help with my problems.

Pain

Ode to pain.
I can't escape you, for you are everywhere.
You are deep inside me,
in my joints, my muscles, and my brain.
You never cease; you only grow.
From day to night, you're never light.
Nothing that I do gets rid of you.
You'll follow me until I die.
Twenty-four years and counting,
You've stayed consistent and never wavered.
Most days, I hate you
because I can barely survive you.
Day by day, I feel you, Pain.
No yoga, no meds will completely take you away.
You always linger in my body.
I don't remember a time I did not have you.
Why do I have so much pain?
Pain in my soul is disheartening,
but, pain in my body, it haunts me.
It never lets me go; it never subsides.
I just have to deal with the pain inside.
Maybe in death I'll finally rest.
My bones feel tired from all of this pain.
How I wish this pain would go away.
Stupid Fibromyalgia,
you're what's causing all my pain.

Change

Am I enough to change the world?
Who am I kidding?
Of course, I'm not.
If only I could help at least one person.
Maybe then,
living would not be in vain.
I don't need to be a hero.
I don't intend to be a mercenary.
I simply feel the need to take action.
But it's hard to get out of my shell.
My heart says I need to do something.
Yet my mind keeps putting me through hell.
The hundred voices in my head
say for me to forget it.
That I lack the resources to
help make a change.
That I was born to sit silently,
content with who I am.
My heart still doesn't give up.
However, it believes in me,
even when I don't.

Complicated

Such is life,
That you won't expect it.
It will sneak up on you,
so you won't detect it.
You must stay aware
because it will come for you,
that one problem that you've been evading.
That's how life is always complicated.
There are no true answers.
There is just prevailing.

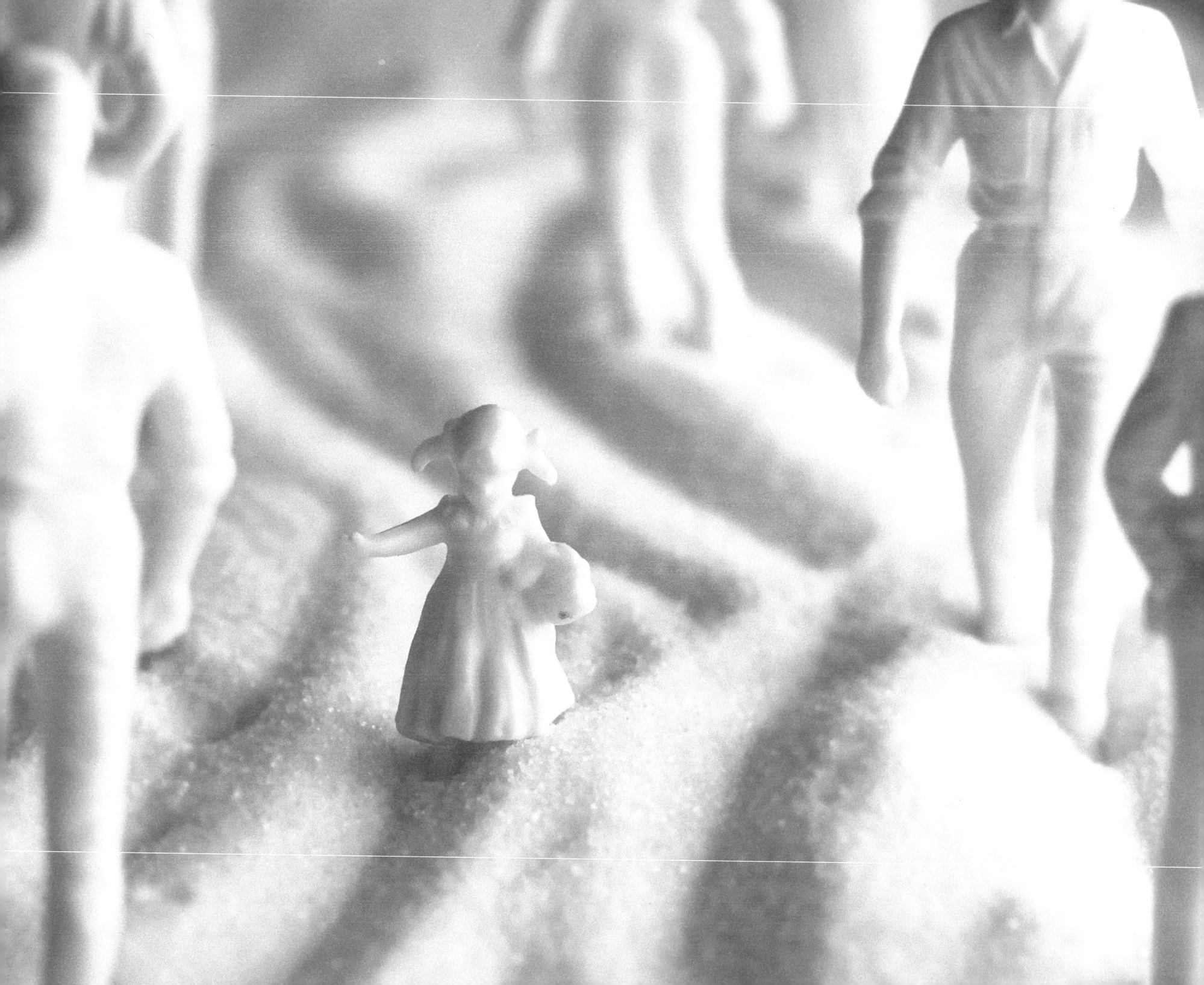

MISERABLE

I wish life had been different.
I wish it had been kind.
Dwelling on the past
has only made me somber.
The past is not the past for me.
It only haunts me,
and it sticks to me like glue.
No matter what my present brings,
It won't erase what I've been through.
I've felt such sadness in my soul,
and it's only now letting me go.
I still get flashbacks
of the darkness in the wardrobe
and of the cold that seeped into my bones.
There were no kind words from her,
only constant yelling
of all her hateful words.
An accident, she liked to remind me.
Not something wanted nor adored.
I begged for love.
She only laughed
and fed me lies that broke my trust.
She showed me how malicious some adults can be.
She left me broken, miserable, and confused.
In spite of everything,
I still survived.
A little mental, but it's due to the hurt inside.

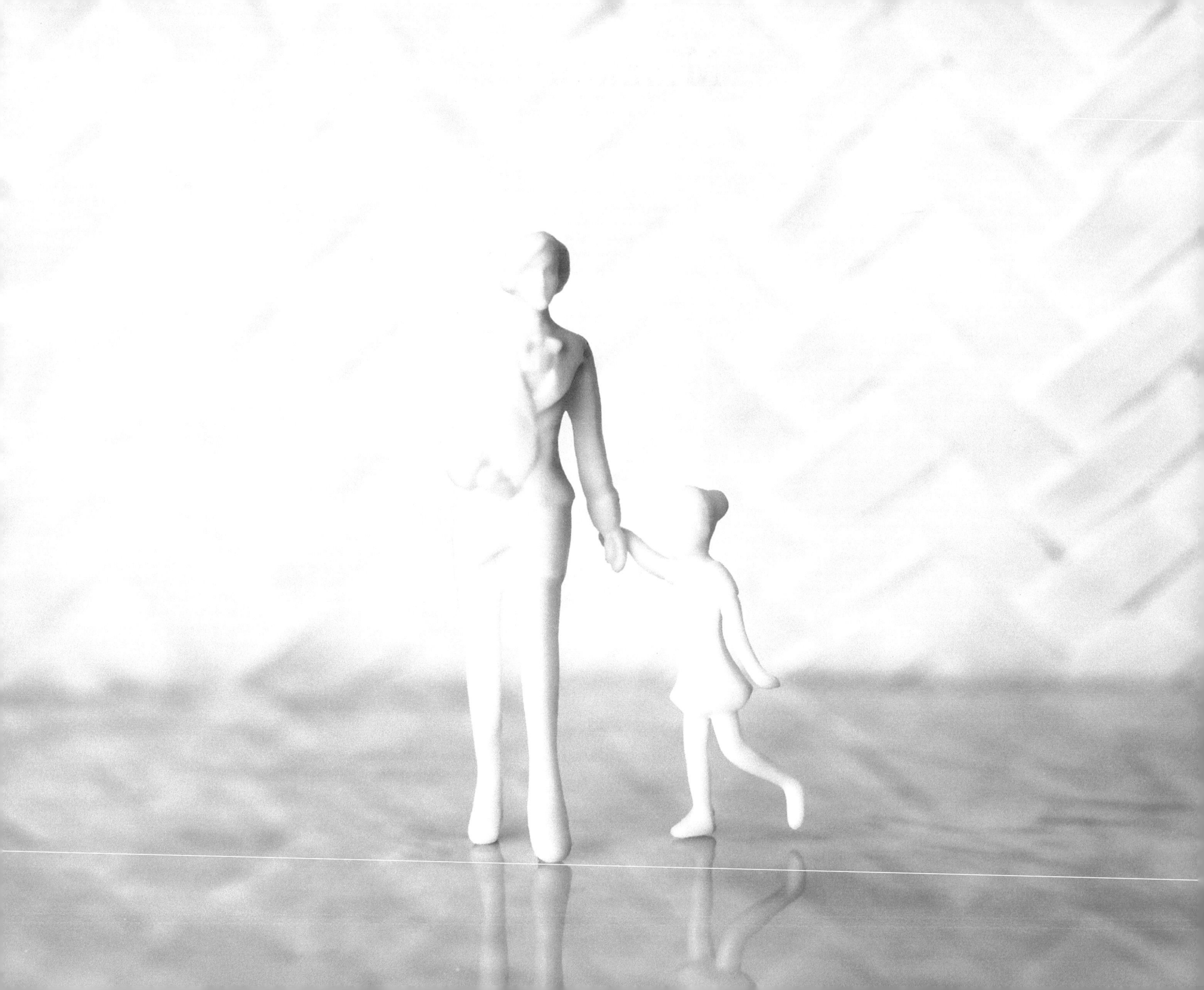

Pretty

There's a little girl I know
who's as pretty as can be.
A special little princess who likes to dress like me.
She learned to read and write,
and now writes letters just for me.
With her lovely smile
and her bright-green eyes,
she brings joy to my world
and is helping heal my heart.
My little sister is the cutest thing I've ever seen.
She is a happier and sweeter version of little old me.
She is the biggest reason I have to succeed.
I will do anything to keep her from being hurt like me.
Fortunately, she has a different mother
who gives her all the love and attention she needs.
My little sister, she means the world to me.
Watching her grow up healthy, loved, and safe
Is slowly healing the aching part of me.

Feel

You feel; they feel; we all feel.
And therefore,
by putting ink to paper,
we relieve the soul
and reclaim a piece of sanity
that is needed to survive.
When feelings overwhelm,
our bubble must be burst
so we may begin to adapt and live
In the world as it is now.
Take heed.
Adapting does not mean selling out.
It is simply being resilient.
We can continue to suppress our feelings,
as many of us were taught.
Or we can acknowledge
that we have issues
and seek help for our hurting minds.

A coping method I was taught
was writing my feelings down.
The relief that came thereafter
was certainly not expected.
And that's what made it so addicting.
It was similar to getting a hug from my dog
after a hectic, long workday.
Putting ink to paper
may not dissolve your problems,
but it helps console the soul.
Adapting to a life without mental abuse
can be pretty hard.
Though the years may have left you scarred,
we all deserve to finally know
what stability feels like.

www.ingramcontent.com/pod-product-compliance
Lightning Source LLC
Chambersburg PA
CBHW050035180526
45172CB00005B/1174